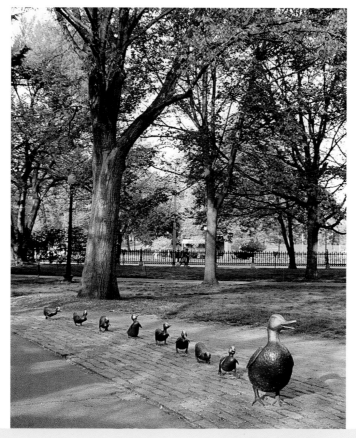

DUCKS ON PARADE!

EDITED BY NANCY SCHÖN

Brandeis University Press • *Waltham, Massachusetts*

FOREWORD

Few works of art hold such a special place in so many hearts as Nancy Schön's Make Way for Ducklings sculpture in Boston's Public Garden. This tribute to one of the greatest American children's books has become one of our city's most iconic landmarks.

Soon after Mrs. Mallard and her eight ducklings made their home there in 1987 they took on lives of their own. The people of Boston didn't just admire the new sculpture, they embraced it with open arms. People started adorning the ducks with holiday decorations and symbols of Boston pride. A new Boston tradition took off, and it's here to stay.

On any given day, you can walk through the Public Garden and find the Mallard family dressed up to reflect either the current cultural moment or to signify historic milestones in Boston's history. You'll see tributes to holidays and sports teams, and you'll see serious reflections on our country's political climate, too. In that way, Nancy Schön didn't just create one of our city's most beloved works of public art; she also gave us a living record of life in our city, and encouraged us all to become artists and reflect on the moment we're living in.

Some of the most creative, inspiring, and moving examples of this are captured in this book. It shows the broad range of experiences and emotions that people have expressed through simple symbols and elaborate costumes. But to see firsthand why this Boston tradition has endured through all these years, you'll just have to visit Mrs. Mallard and her ducklings yourself!

Martin J. Walsh, Mayor of Boston

INTRODUCTION

Robert McCloskey wrote *Make Way For Ducklings* in 1941 and it remains one of the most beloved of children's books. I was fortunate to be commissioned in 1987 to create the bronze sculpture of Mrs. Mallard and her brood that is in the Public Garden.

The following year, the ducklings had their first birthday with duck cookies, duck punch, ice cream, and a big birthday cake. The ducklings were decorated with colorful birthday hats and confetti. Soon after, mysterious people began dressing the ducklings according to a particular holiday, or to express their support of a sports team. This outpouring of creativity extended into protests, political, or grief statements, such as after the Boston Marathon Bombing. Those who dress them are still unknown; there is hardly a time now that the Boston ducks are bare.

I marvel at the love and care that goes into each outfit, and the unique way people express their feelings. I am in awe of the generous time dedicated by those who sew each stitch to make a perfect little costume for every duckling. There is a special connection between the people of Boston and these sculptures that brings us together.

Many times, I have watched the way children play with the ducklings. They pretend to feed them and have fun sitting on each of them of them in turn, starting with Jack, to Kack, Lack, Mack, Nack, Ouack, Pack proceeding all the way to Quack. They talk to them as though they were real. Parents and grandparents, camera in hand, catch that magic moment of joy when their child hugs a duckling.

It was with all this in mind that I decided to create this book with photographs taken

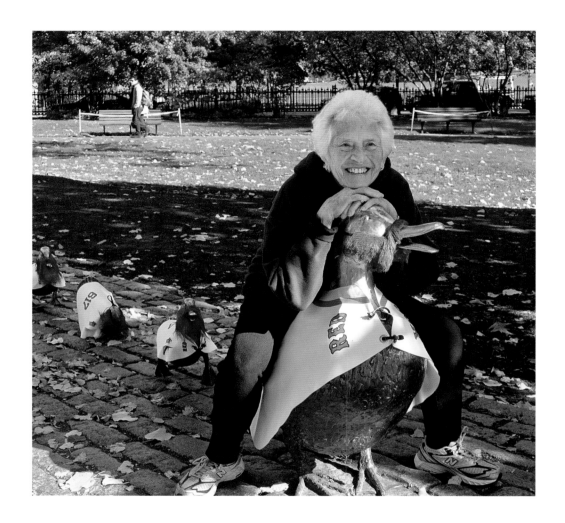

NANCY SCHÖN

by the people of Boston, who obviously find as much pleasure as I do in seeing the ducks all decked out. I can see how these simple little bronze ducklings came to represent a record of the recent decades of life in our city. This book is a tribute to all Bostonians whose creativity and generosity have made this possible. Furthermore, it is an historic record showing the power of public art.

With enormous gratitude to all those who have sewed and knitted, and who have also taken the photographs.

Affectionately,

Nancy Schön

Nancy Schön

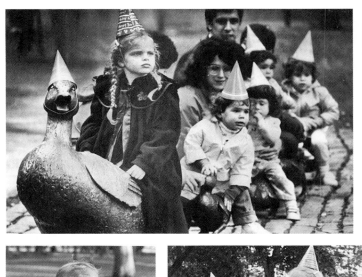
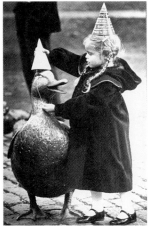
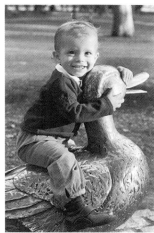
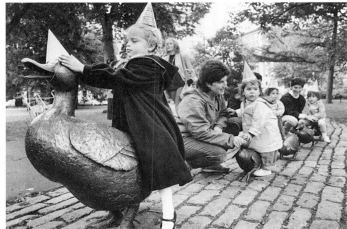

THE DUCKLINGS FIRST BIRTHDAY

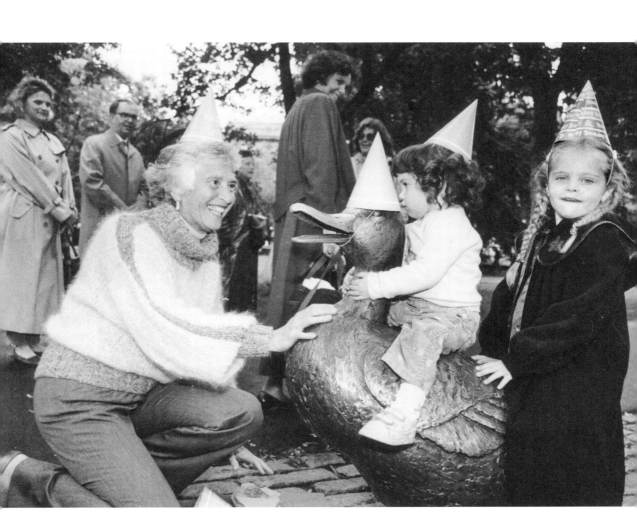

OCTOBER 4TH, 1988

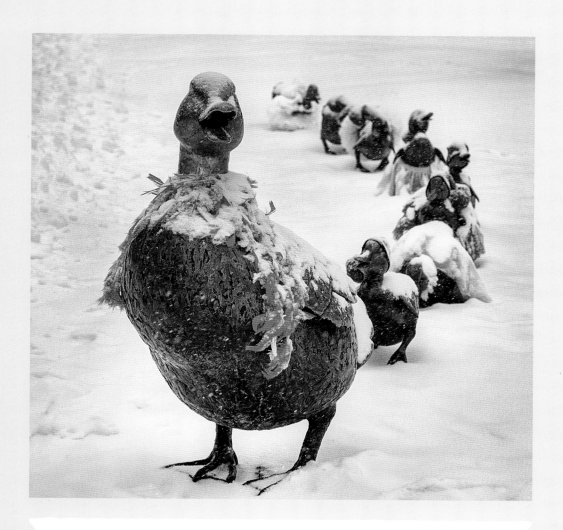

FOUR SEASONS OF DUCKS

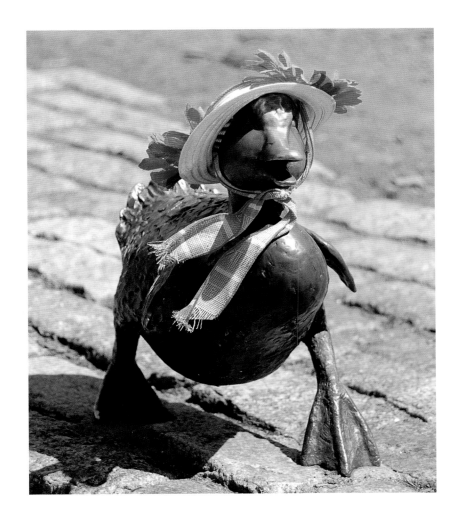

SPRING PARADE

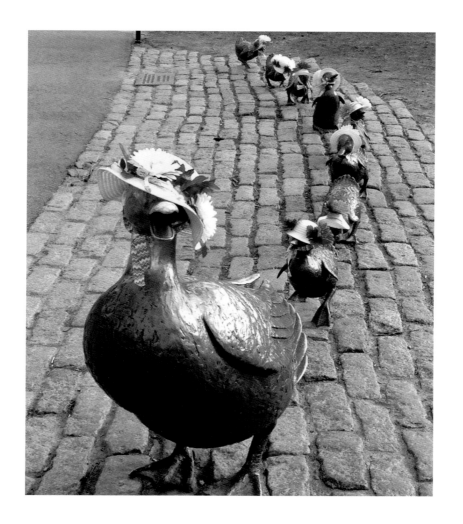

SPRING PARADE

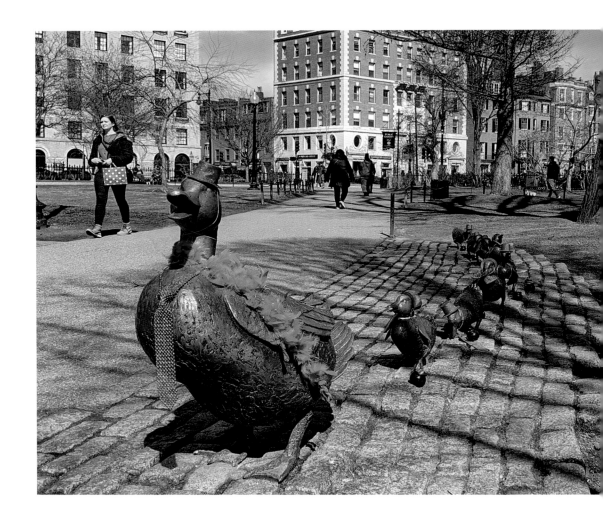

ST. PATRICK'S DUCKS

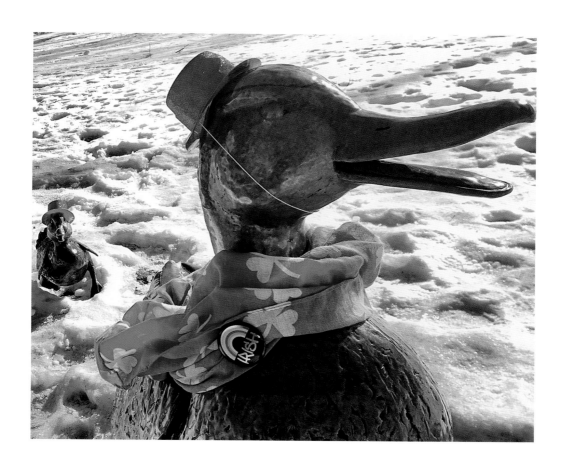

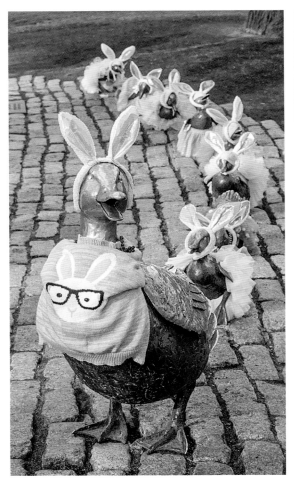
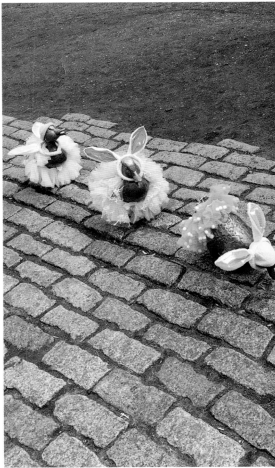

EASTER BUNNY DUCKS

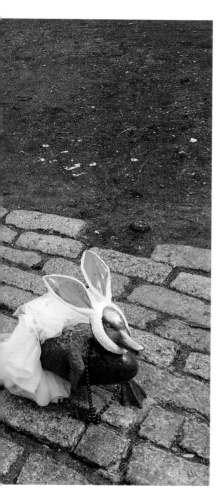
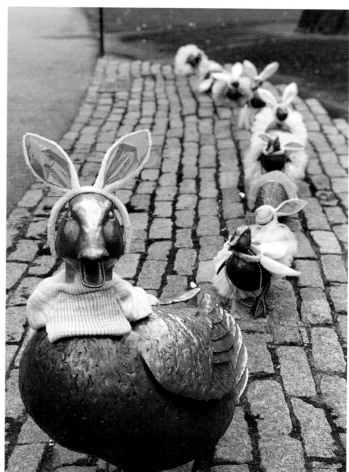

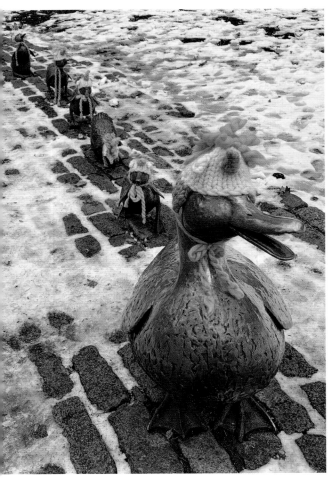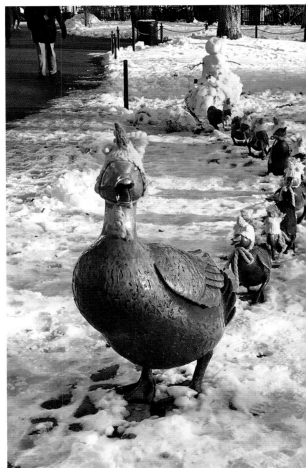

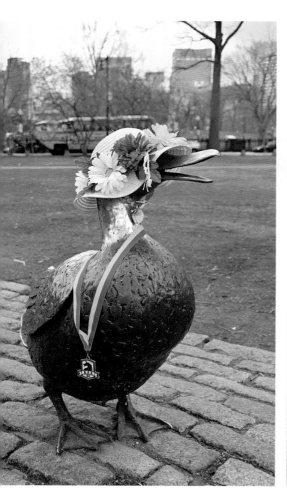
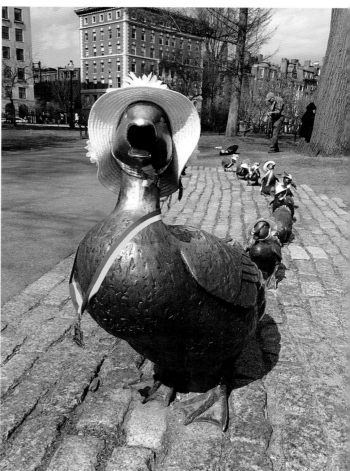

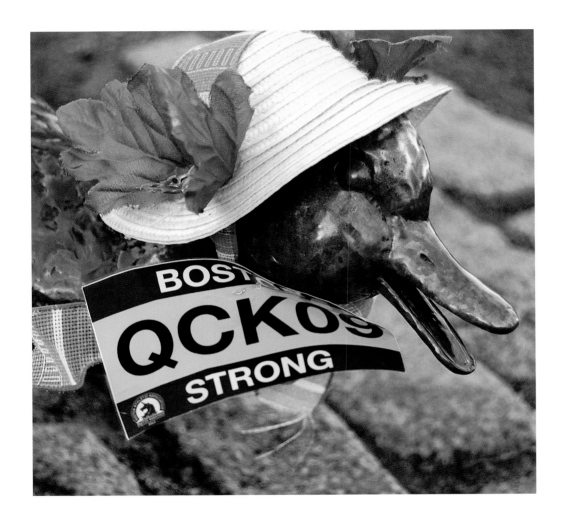

BOSTON STRONG

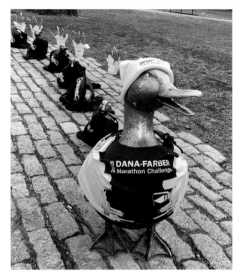
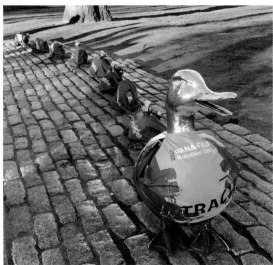
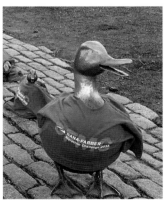
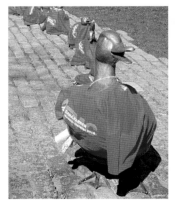
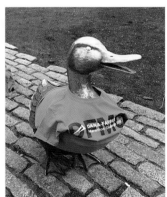

SUPPORTING THE DANA FARBER CANCER INSTITUTE

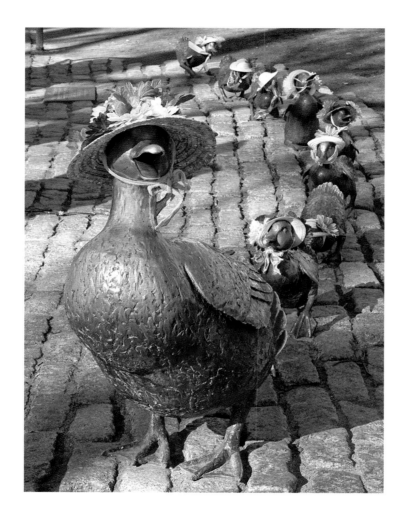

MOTHER'S DAY STROLL

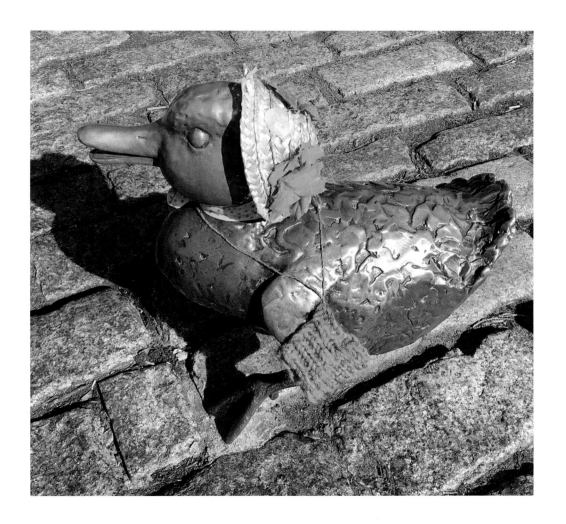

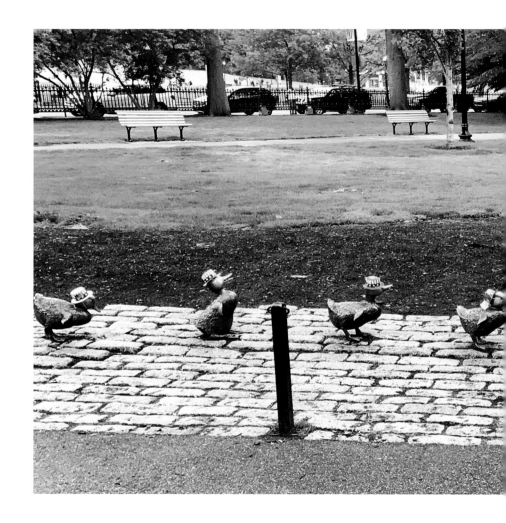

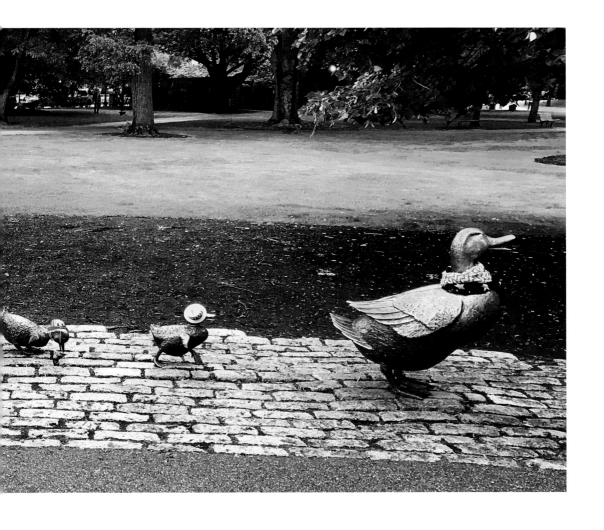

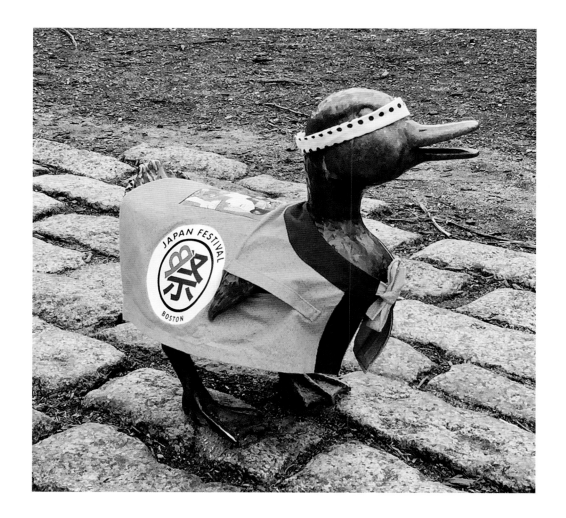

JAPAN COMES TO BOSTON

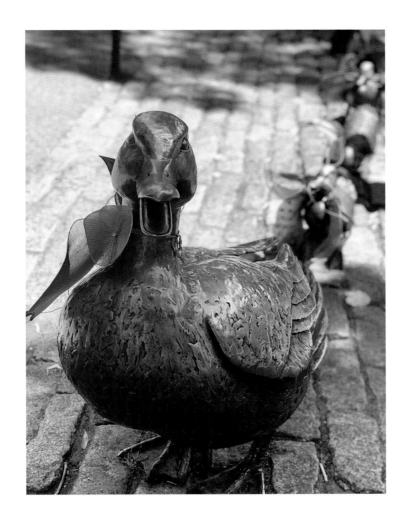

BASTILLE DAY

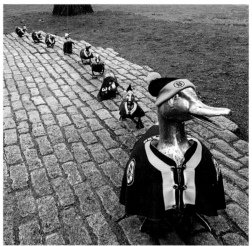
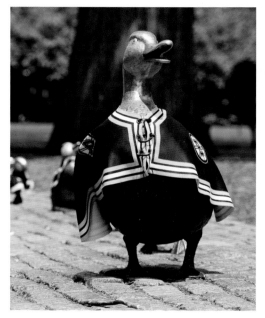

THE BOSTON BRUINS

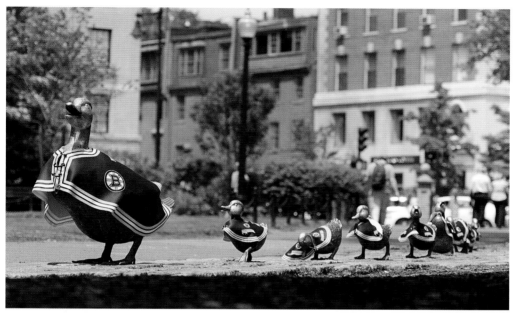

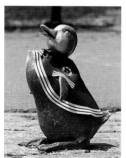
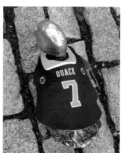
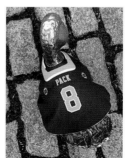
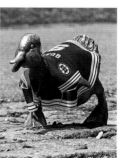

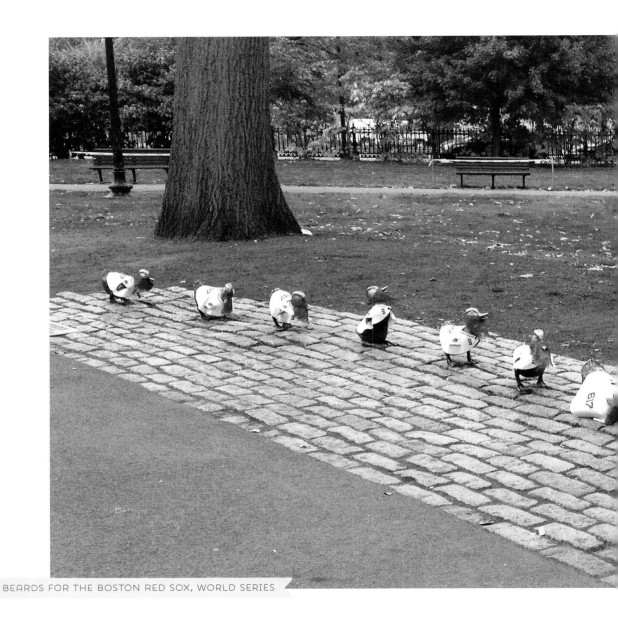

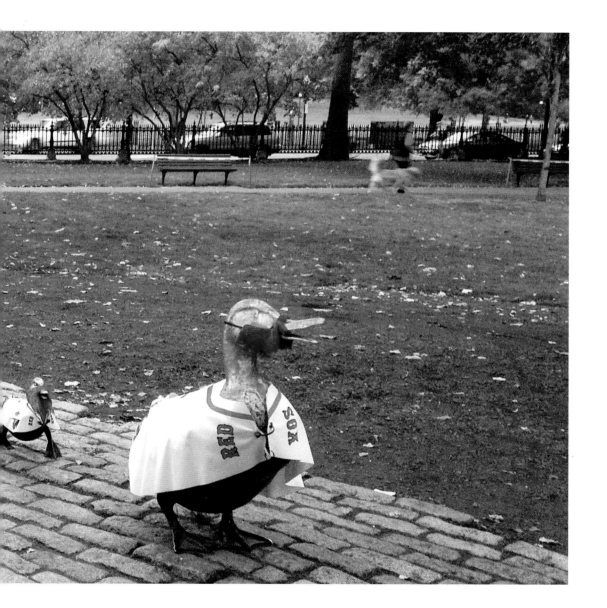

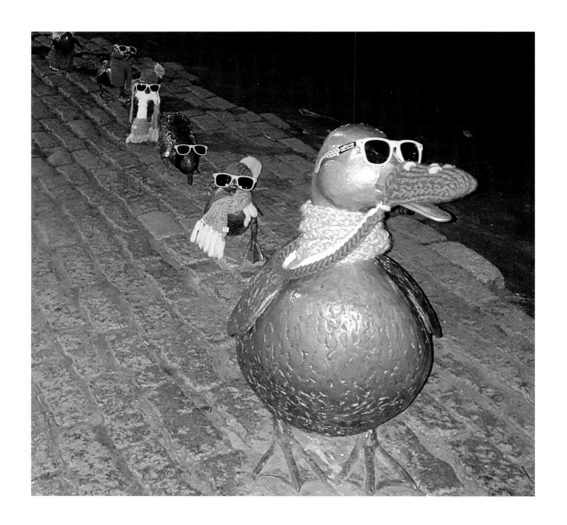

HAPPY HALLOWEEN!

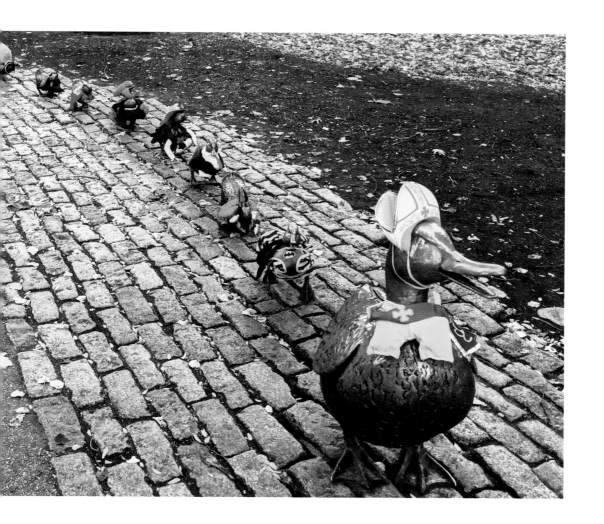

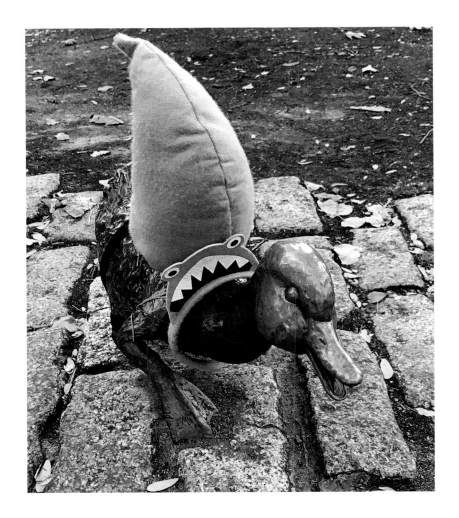

SHARK ATTACK!

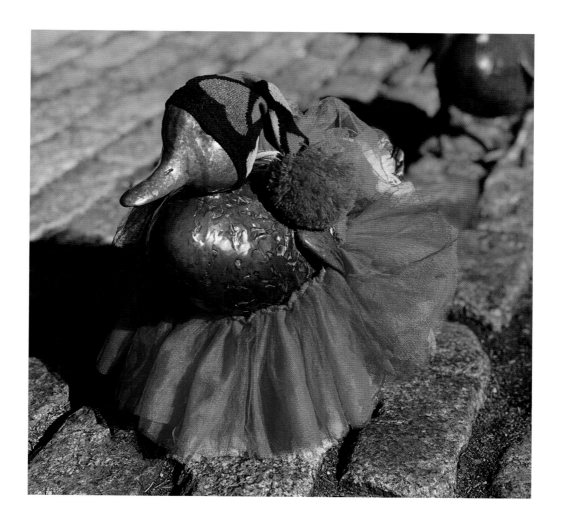

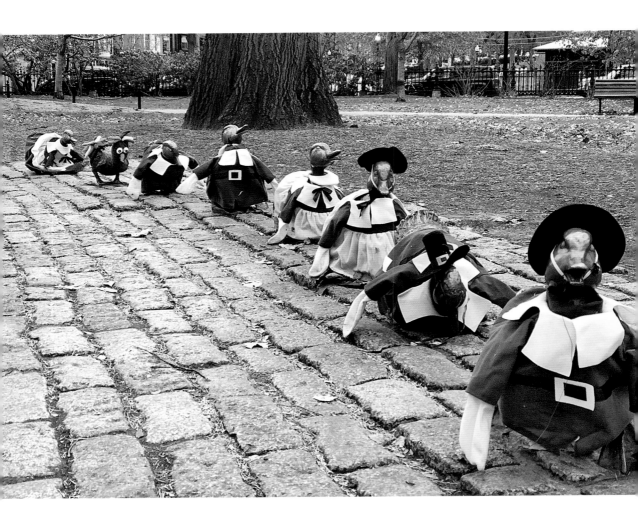

THANKSGIVING IN THE GARDEN

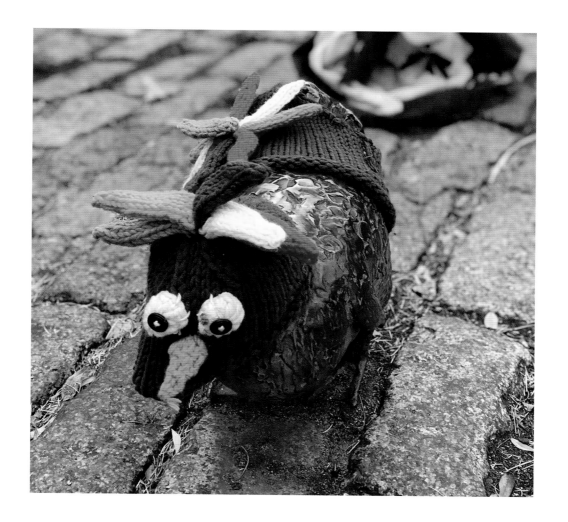

DUCK OR TURKEY?

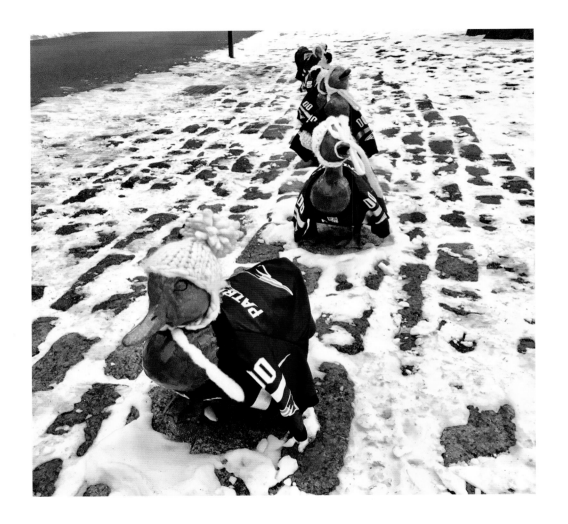

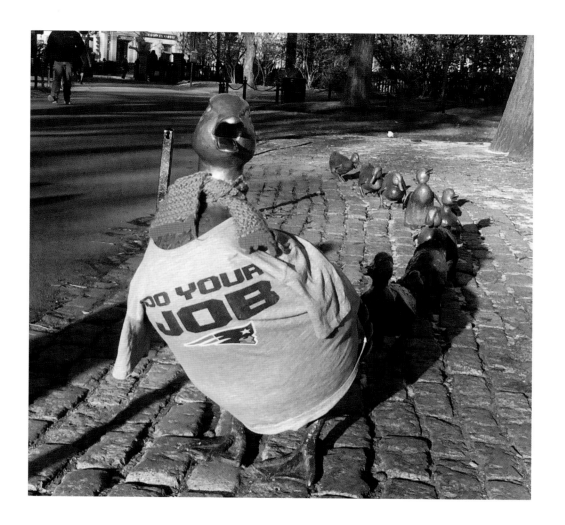

GO PATS!

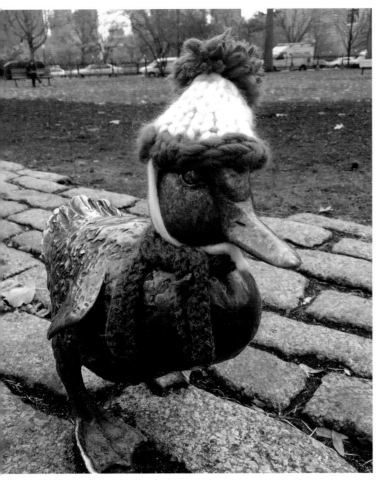
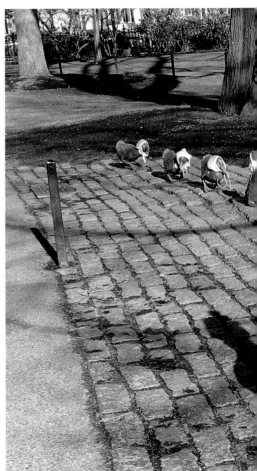

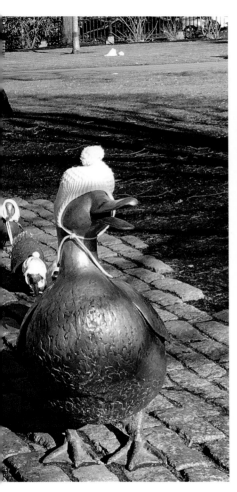
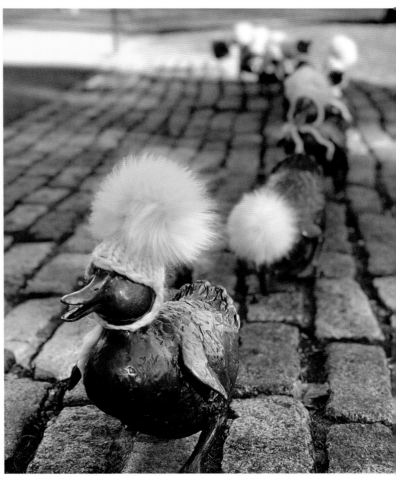

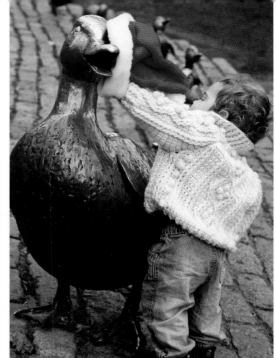
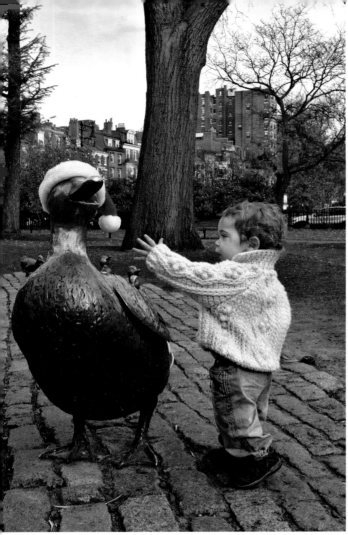
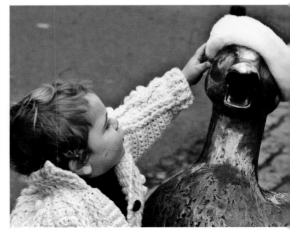

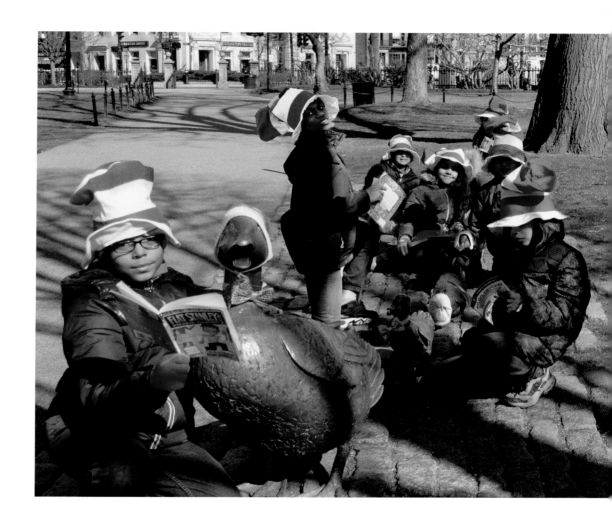

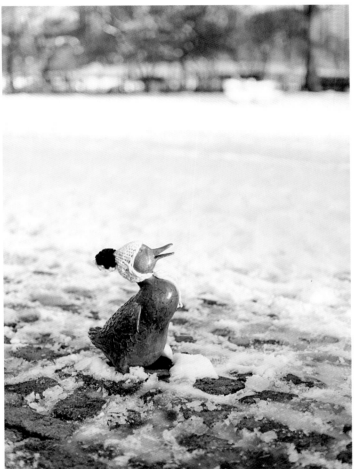

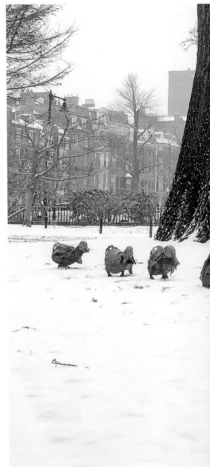

NACK, ALONE AT LAST!

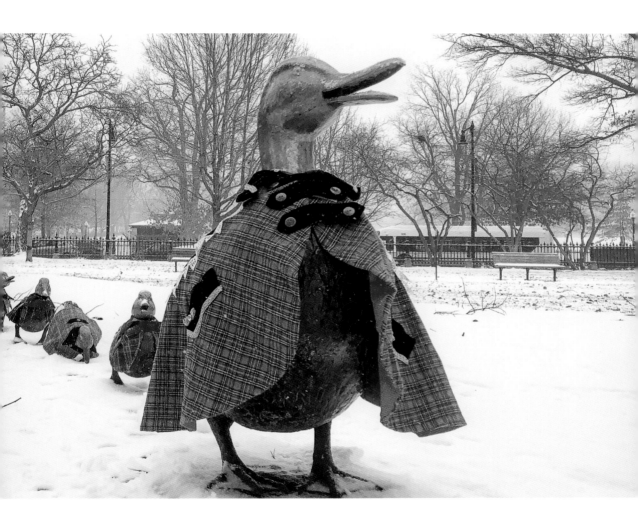

SCOTTISH DUCKS

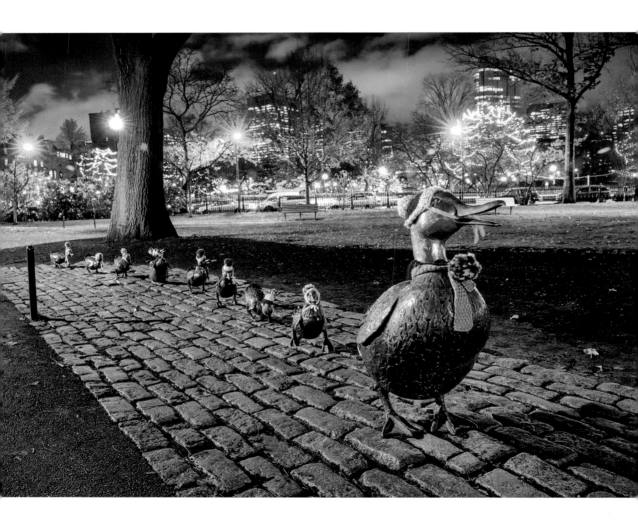

HAPPY HOLIDAY DUCKS

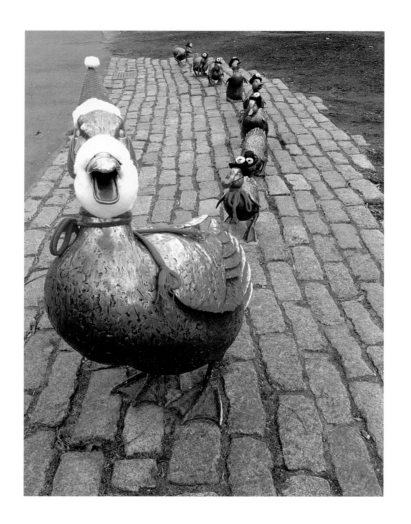

HAPPY HOLIDAY DUCKS

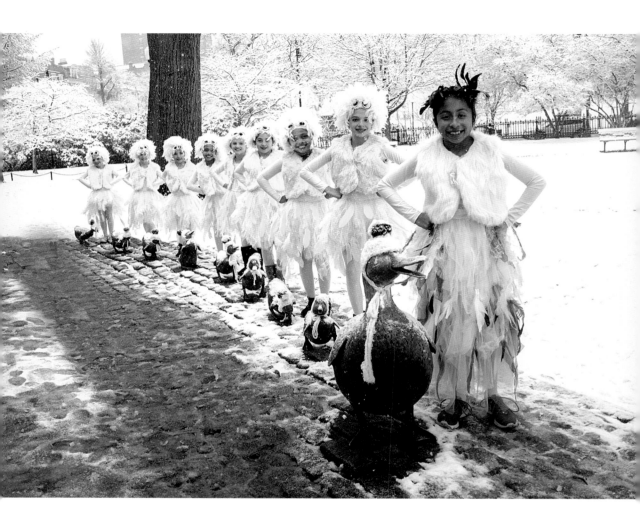

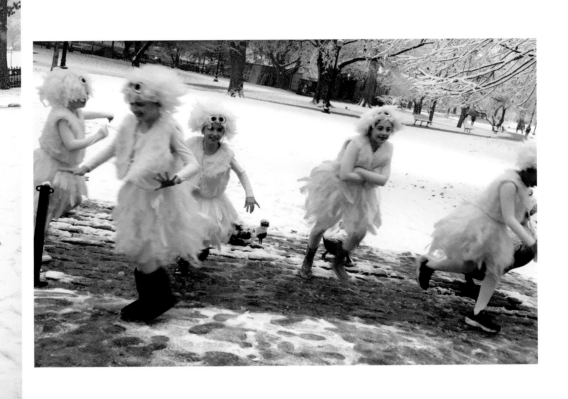

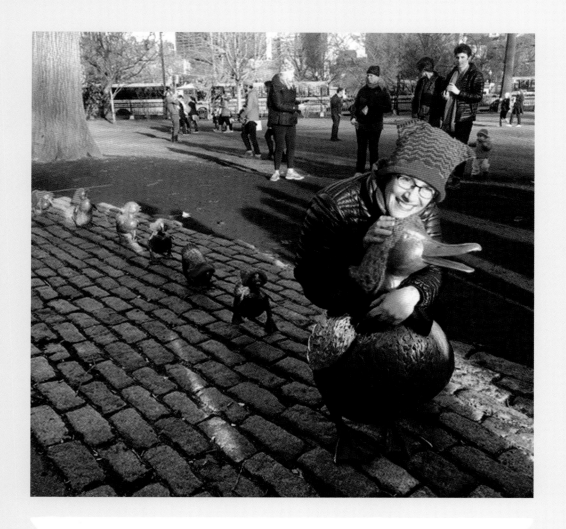

DUCKS WITH A MESSAGE

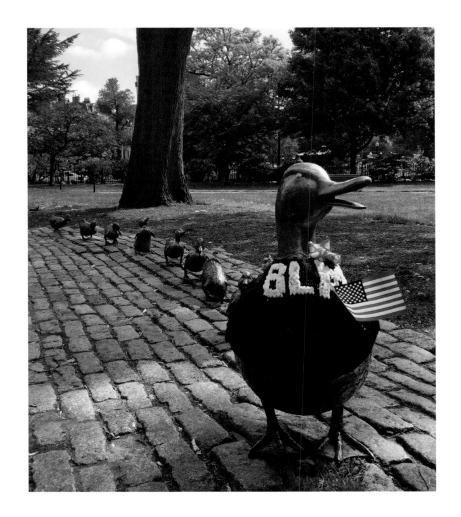

BLACK LIVES MATTER

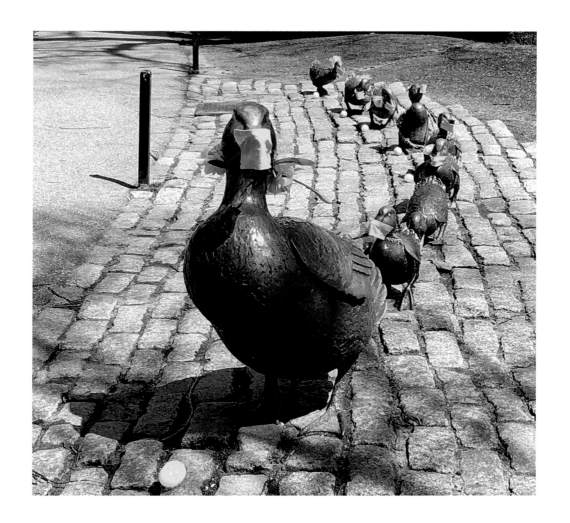

EASTER DUCKS IN QUARANTINE

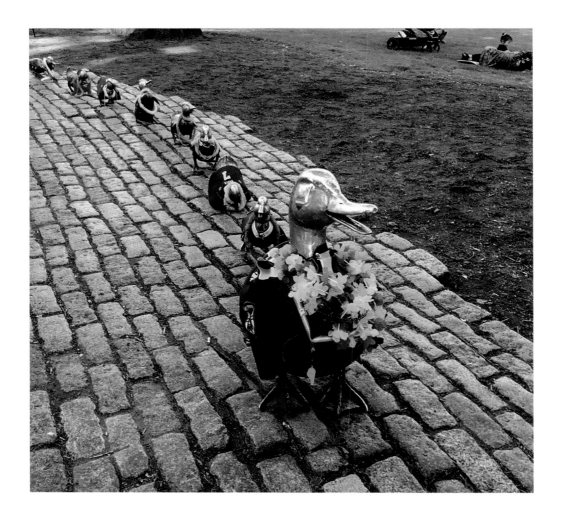

MARCHING WITH PRIDE

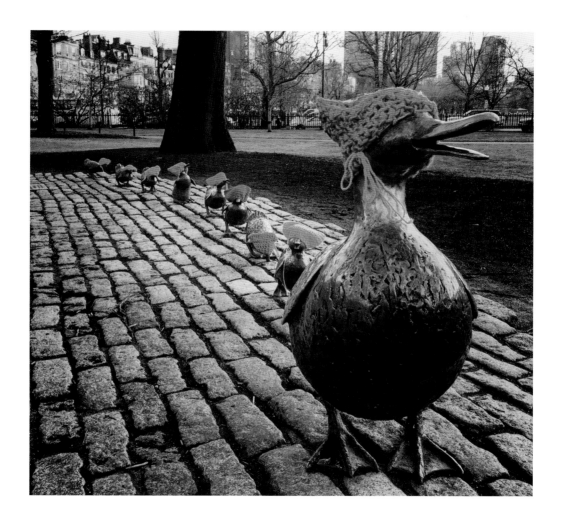

MARCHING FOR WOMEN

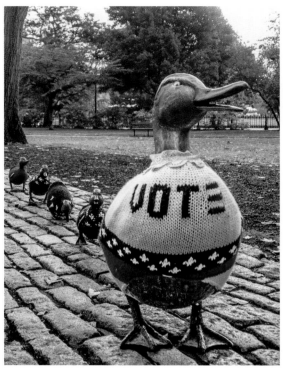

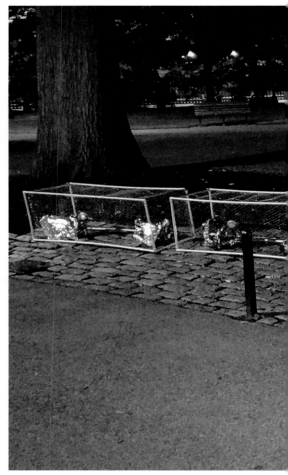

DUCKS VOTE TOO!

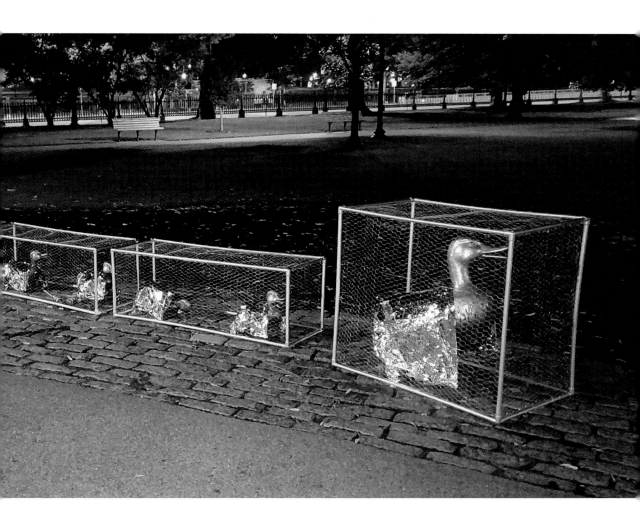

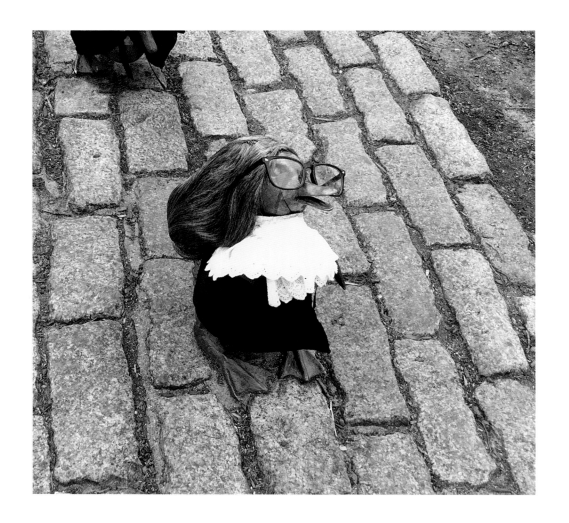

RUTH BADER GINSDUCK

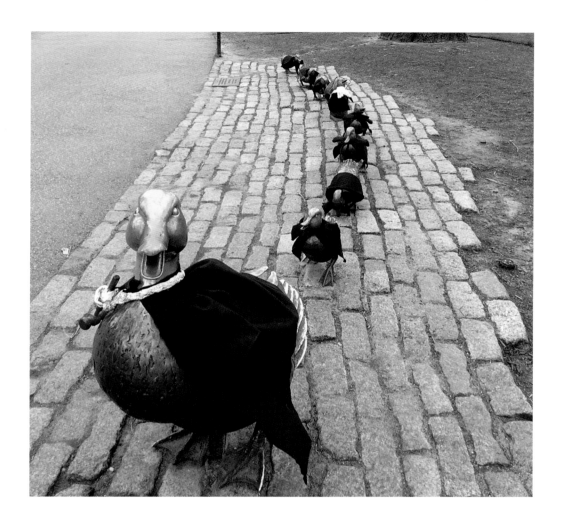

JUSTICE FOR ALL

ЭТА СКУЛЬПТУРА — ПОДАРОК ДЕТЯМ СОВЕТСКОГО СОЮЗА
ОТ ДЕТЕЙ СОЕДИНЕННЫХ ШТАТОВ
В ДУХЕ ЛЮБВИ И ДРУЖБЫ.
ЗАМЫСЕЛ СКУЛЬПТУРЫ ВЗЯТ ИЗ
ЛЮБИМОЙ АМЕРИКАНСКОЙ СКАЗКИ ДЛЯ ДЕТЕЙ
«ДОРОГУ УТЯТАМ», НАПИСАННОЙ РОБЕРТОМ МАККЛОСКИ.
СКУЛЬПТОР — НЭНСИ ШЁН.

1991
ПРЕПОДНЕСЕНО БАРБАРОЙ БУШ

———

THIS SCULPTURE IS GIVEN IN LOVE AND FRIENDSHIP TO
THE CHILDREN OF THE SOVIET UNION
ON BEHALF OF
THE CHILDREN OF THE UNITED STATES
IT IS BASED ON THE BELOVED AMERICAN CHILDREN'S STORY
"MAKE WAY FOR DUCKLINGS" BY ROBERT McCLOSKEY
THE SCULPTRESS IS NANCY SCHÖN

1991
PRESENTED BY MRS. BARBARA BUSH

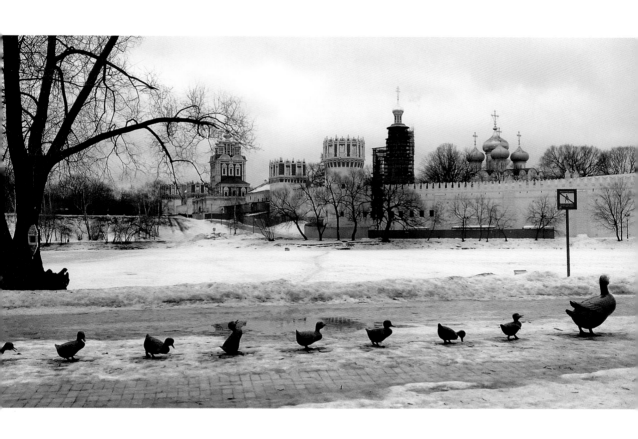

THE DUCKS IN NOVODEVICHY PARK

THE BOSTON PUBLIC GARDEN

The Boston Public Garden is the first public botanical garden in America. Its form, plantings, and statuary evoke its Victorian heritage. No visit to this Boston icon would be complete without a stopover at one of Boston's most beloved destinations, the Ducklings Sculpture. The family of nine—a mother and her eight offspring—have lived in the Public Garden for over 30 years. When Henry Lee, then President of the Friends of the Public Garden, was approached about the possibility of adding a new piece of art to the Garden, he welcomed the idea and worked with Nancy Schön to make it a reality. The sculpture was presented to the City by the Friends in 1987 "as a tribute to Robert McCloskey, whose story *Make Way For Ducklings* has made the Boston Public Garden familiar to children throughout the world," as the plaque at the site reads.

In our 50th year, the Friends of the Public Garden cares for this fashionable Duckling family, along with 41 other sculptures, tablets, plaques and fountains in the three parks. Along with our partner, the City of Boston, we ensure this significant collection is maintained in excellent condition. The Ducklings are so kid-friendly and well-loved, we can say, without reservation, this avian family is the most cherished statue in the entire City!

Leslie Singleton Adam, Chair of the Board *Liz Vizza, Executive director*

ACKNOWLEDGMENTS

There is almost nothing I do in which my children and their spouses are not involved. They are my constant support and consummate love, and are always there for me. How incredibly fortunate am I to be able to say the same of my eleven loving grandchildren and their spouses.

However, I have to give particular thanks to my grandson Ben who, with his technological know-how and understanding of his Nanny's lack thereof, set up a system that even I could navigate with ease. My granddaughter Mia, with her kindness and creativity was also right there, patiently helping, one click away. And my granddaughter Jackie added her expertise, always willing to help on a minute's notice.

Although not a member of the family, but close to it, Victor Salvucci, constantly saves us in this electronic jungle. I thank him for his genius.

I'd like to thank Sue Ramin, my publisher at Brandeis University Press whose wit and wisdom was the inspiration for this book, who guided us through the maze of decisions that made this beautiful book what it is. Lillian Dunaj at BUP whose organizational skills kept track of the photographers and the permissions always with a sweet willing spirit. Lisa Diercks for her hard work, her imagination, inventiveness, and brilliant design. Doug Tifft at Redwing for his production expertise and worldly advice.

A big thanks to the Friends of the Public Garden for their longtime stewardship of the ducklings. A shout-out to President Emeritus Henry Lee, founder of the extraordinary Friends of the Public Garden, whose sponsorship of the sculpture in 1985 brought it

to reality. Elizabeth Vizzi, Executive Director, and Susan Abell, President of the Board, are continuing with the task of maintaining the Garden's extraordinary beauty.

I am indebted to the late Robert McCloskey, author of *Make Way for Ducklings*, for commissioning me to fashion, from his drawings, this bronze sculpture which has found its way in to the hearts of the people of Boston.

Last but hardly least, I thank my many friends, for supporting me over the years with their love and caring through the adventures of my long and fascinating life.

Nancy Schön
Newton, Summer 2020

For permission to reproduce any of the material
in this book, contact Brandeis University Press,
415 South Street, Waltham MA 02453, or visit
brandeis.edu/press

First published by Brandeis University Press 2021

Library of Congress Cataloging-in-Publication Data
Schön, Nancy, 1928– editor.
Ducks on parade! / edited by Nancy Schön.
Waltham, Massachusetts : Brandeis University
Press, 2021.
LCCN 2020033709 | ISBN 9781684580415 (cloth)
LCSH: Schön, Nancy, 1928– Make way for
ducklings—Pictorial works. | Public Garden
(Boston, Mass.)—Pictorial works.
NB237.S377 A68 2021 | 730.9744/61—dc23
LC record available at
https://lccn.loc.gov/2020033709

Book and cover design by
Lisa Diercks / Endpaper Studio
Typeset in Showcase and Hightower

Printed in China
10 9 8 7 6 5 4 3 2 1

IMAGE CREDITS

Cover: Courtesy of Charlene Entwistle James.
Interior: Photos on pages 1 and 64 courtesy of Helen Eddy, Cambridge, MA (www.heleneddy.com). Photo on page 4 courtesy of Mia Schön. Photos on page 6 (top left, top right, and bottom right) and page 7 are from the editor's personal collection, courtesy of photographer, Ted Fitzgerald. Photo on page 6 (bottom left) is from the personal collection of Peter S. Lynch, courtesy of photographer Cheryl Richards. Photos on pages 9, 14, and 44: "A Kyle Klein photo." Photos on pages 10, 15 (right), 17 (left), 18, 25, 33, 34, 35, 38, and 39 (right), courtesy of Gisela Nilsson. Photo on page 11 courtesy of Adelaide Donnelly. Photos on page 12 and 31 courtesy of Chris Vlamis. Photo on page 13 courtesy of Laurel R. T. Ruma. Photo on page 15 (left) courtesy of Linda L. Greyser. Photo one page 16 (left) courtesy of Diane Britton. Photo on page 16 (right) courtesy of Sally Casper. Photos on page 17 (right), 22, 36, and 37 courtesy of Rachel Marco. Photos on page 19 courtesy of Tracy L. Saperstein. Photo on page 20 courtesy of Charlene Entwistle James. Photo on page 21 courtesy of Louise (Weezie) B. Gilpin. Photo on page 24 courtesy of Alice Grossman. Photos on pages 26 (top left and top middle), and 27 (middle left and middle right) courtesy of Nancy R. Coolidge. Photo on page 26 (top right) courtesy of Anita Lincoln. Photos on pages 26 (bottom right) and 40 courtesy of Mary Schiess. Photos on pages 26 (bottom left) and 27 (top, bottom left, and bottom right) courtesy of Scott Cluett. Photo on page 29 courtesy of Hannalea Howell. Photo on page 30 courtesy of Jennifer Beard. Photo on page 32 courtesy of Jennifer Haupt. Photo on page 39 (left) courtesy of Harriet Christina Chu and Chris Chu Architect. Photo on page 41 courtesy of Jan Lewis Plourde, featuring children from The REAL Program, Inc. Photo on page 42 courtesy of Phuong D. Diep. Photo on page 43, and design of duckling jackets, by Lorraine Walsh. Photo on page 45 courtesy of Roland Beliveau. Photo on page 46 courtesy of Dustin Rennells. Photo by Michela West / Mickey West Photography for Tony Williams' Urban Nutcracker. Photo on page 47 courtesy of Dustin Rennells. Photo by Janyne Damesek, 2017 for Tony Williams' Urban Nutcracker. Photo on page 49 courtesy of Nan Andell. Photo on page 50 courtesy of Daniel Campbell-Benson. Photo on page 51 courtesy of Jim Hood. Photo on page 52 courtesy of Joanne Ekhaml. Photo on page 53 courtesy of Allison Kroner Barron. Photo on page 54 courtesy of Paige Baldwin. Photo on page 55 courtesy of Karyn Alzayer. Photos on page 56 and 57 courtesy of Anne Louise C. Van Nostrand. Photo on page 58 from the editor's personal collection. Photo on page 59 courtesy of Tatiana Malkova.

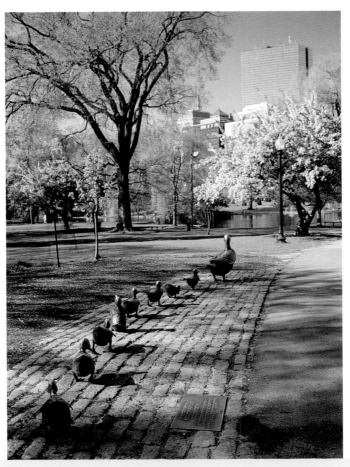

DEDICATED TO THE PEOPLE OF BOSTON